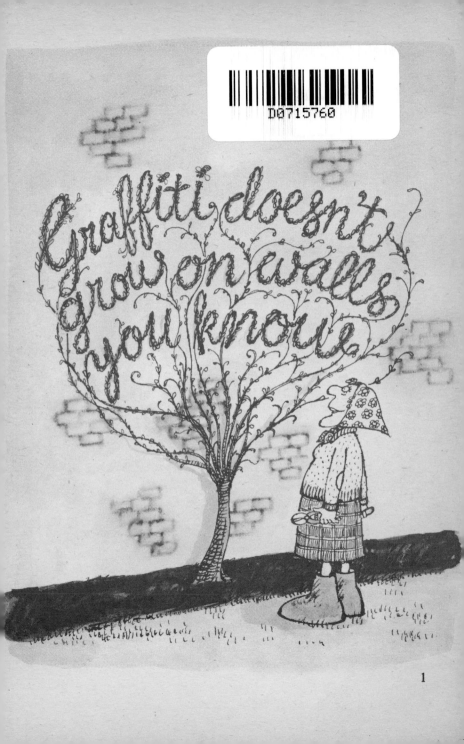

Graffiti doesn't grow on walls you know

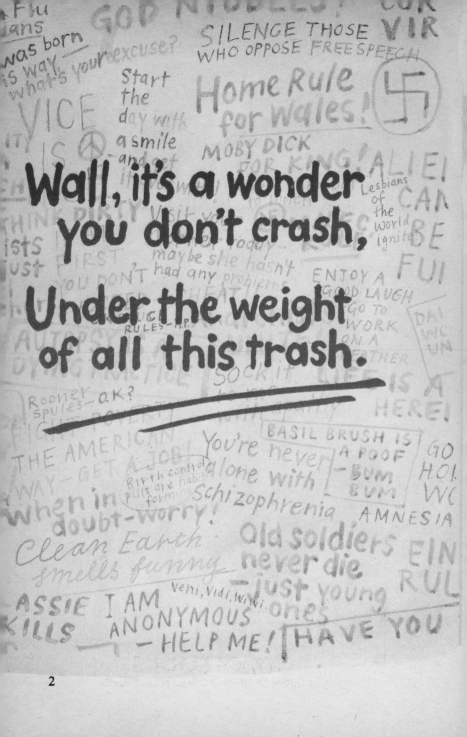

GRAFFITI 2:

THE WALLS OF THE WORLD

More great graffiti of our times
collected and introduced by
ROGER KILROY

Illustrated by

CORGI BOOKS
A DIVISION OF TRANSWORLD PUBLISHERS LTD

GRAFFITI 2: THE WALLS OF THE WORLD
A CORGI BOOK 0 552 98116 8

First publication in Great Britain
Corgi edition published 1980
Text material copyright © 1980 by Roger Kilroy
Illustrations copyright © 1980 by Edward McLachlan

Corgi Books are published by
Transworld Publishers Ltd.,
Century House, 61 - 63 Uxbridge Road, Ealing,
London, W5 5SA

Made and printed in Great Britain by the Guernsey Press Co. Ltd., Guernsey, Channel Islands.

CONTENTS

WELCOME TO THE WALLS OF THE WORLD

This is Mr McLachlan's and my second collection of global graffiti. Our first — Graffiti, The Scrawl of the Wild (Corgi 1979) — swept the world and enabled us to stop sweeping the streets. It also provoked thousands of letters — well three, to be honest — all asking the same thing. Where can we find the best graffiti for ourselves?

And that question from the three of you has prompted this answer from the two of us: right here. Ladies and gentlemen, boys and girls and the rest of you who are either in between or undecided, Kilroy and McLachlan proudly present the world's first Good Graffiti Guide.

Graffiti hunting is an art and you'll waste time and energy if you don't know the tricks of the trade. So join with us as we penetrate the minds of the wall scribes and lead you to the secret and the not-so-secret places, where they unleash their caustic wisdom on an unsuspecting world.

Come graffiti hunting with the pair of us and you'll not only have a few laughs and come face to face with a few home truths (and rather more half truths), you'll also learn a lot about the true nature of society in the eighties.

For example, in the pages that follow, there is much to cheer the forlorn teacher who is convinced that the young have gone to the dogs — or to the horses, or even to bingo. The walls of our schools and colleges at least show one thing — the young still have plenty to say, even if they can't always spell it 'write'.

In fact whatever your profession, your interest or your bent — because some of our graffiti do seem to be a little queer — you will find great inspiration from the Good Graffiti Guide. Just take your notebook and pencil (and your spray can because the graffiti hunter is really a graffiti writer in disguise) and follow us onto the streets but please not into the loo — that's one place where I still like to do private research.

Education kills
by degrees!

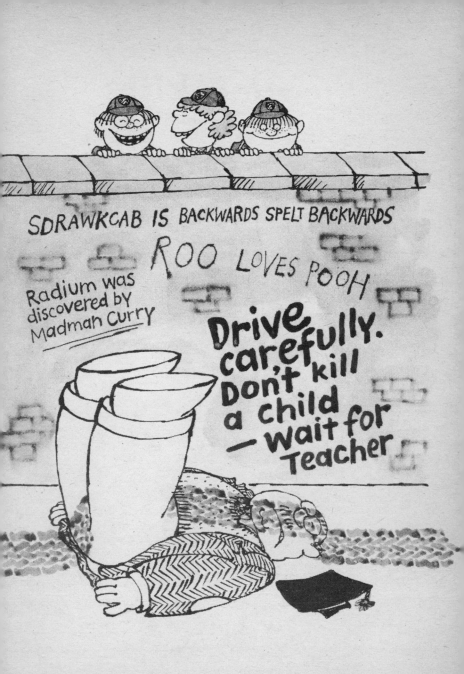

9

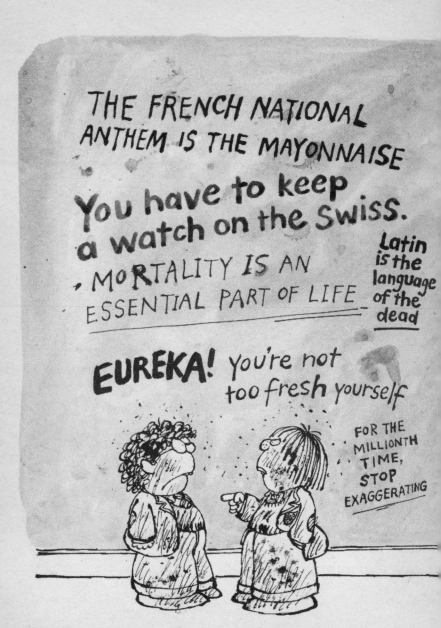

10

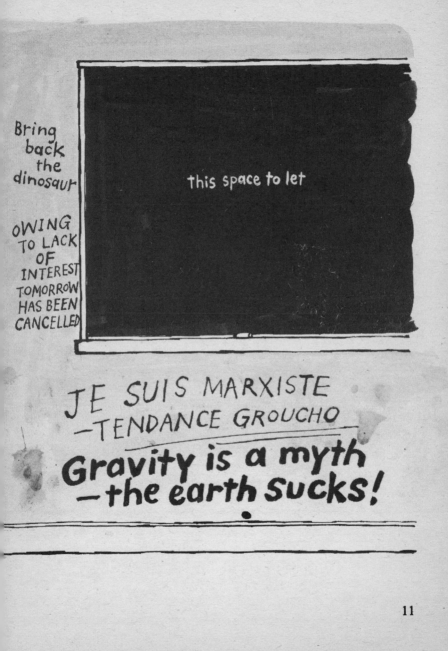

Bring
back
the
dinosaur

OWING
TO LACK
OF
INTEREST
TOMORROW
HAS BEEN
CANCELLED

this space to let

JE SUIS MARXISTE
—TENDANCE GROUCHO

Gravity is a myth
—the earth sucks!

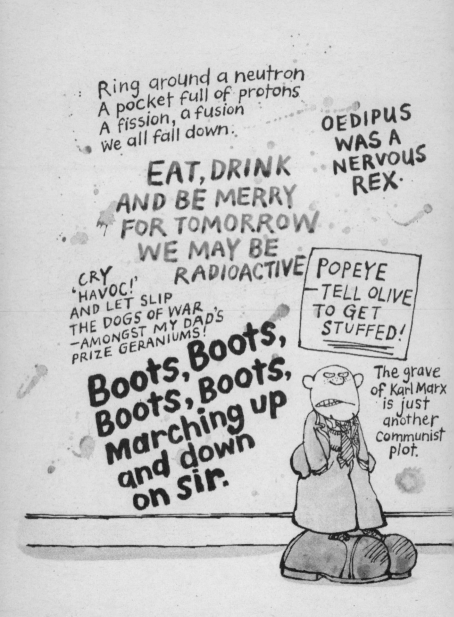

Ring around a neutron
A pocket full of protons
A fission, a fusion
We all fall down.

OEDIPUS WAS A NERVOUS REX.

EAT, DRINK AND BE MERRY FOR TOMORROW WE MAY BE RADIOACTIVE

CRY 'HAVOC!' AND LET SLIP THE DOGS OF WAR —AMONGST MY DAD'S PRIZE GERANIUMS!

POPEYE —TELL OLIVE TO GET STUFFED!

Boots, Boots, Boots, Boots, marching up and down on sir.

The grave of Karl Marx is just another communist plot.

12

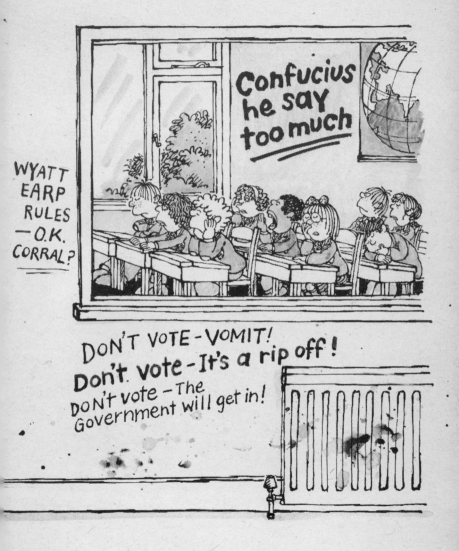

WHEN THE LAST OF THE SOCIOLOGISTS
HAS BEEN STRANGLED WITH THE INTESTINES
OF THE LAST BUREAUCRAT, WILL WE STILL
HAVE PROBLEMS?
ANSWER ON A POSTCARD PLEASE.

100,000 LEMMINGS CAN'T BE WRONG

PROCRASTINATE NOW!

MATRICULATION MAKES YOU DEAF

The world is flat—
Class of 1492

Beware the thundrous trowel surgeons

BAN UNDERAGE DRINKING
Well, I'm sweet sixteen
and never been pissed.

DO YOU HAVE TROUBLE
IN MAKING UP YOUR MIND?
—Well, yes and no.

TO DO IS TO BE — Rousseau	TO BE IS TO DO — Sartre	DOBEDOBEDO — Sinatra

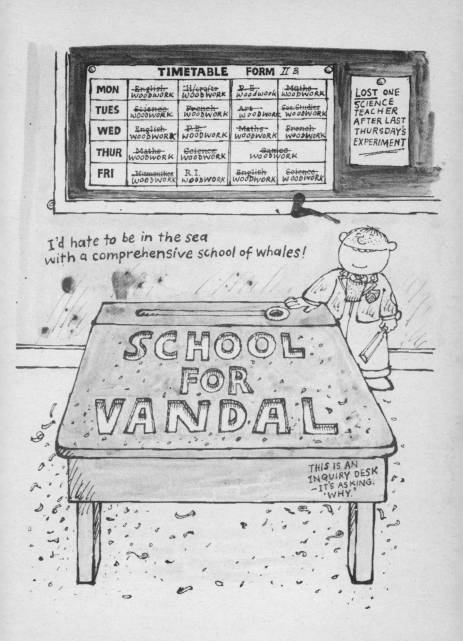

Bruce Lee is not dead — He's just kicking around somewhere!

A pessimist is a man who looks after your feet — NO THAT'S A PEDOPHILE YOU FOOL

RICHARD CŒUR DE LION — FIRST HEART TRANSPLANT

join the hernia society — it needs your support

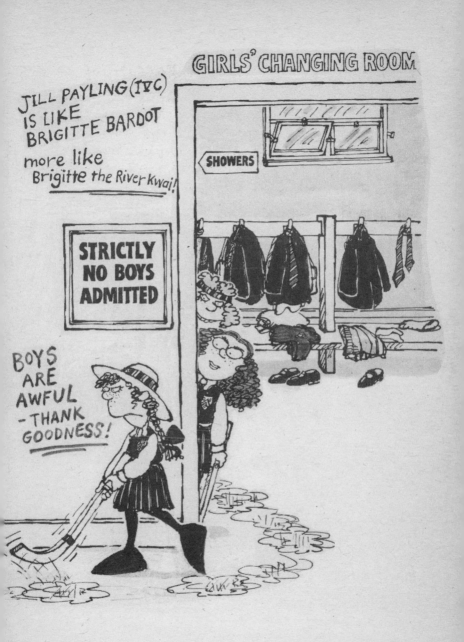

17

Business as usual.
(Full stop)

Six munfs ago I cudn't even spel executiv. Now I are wun.

THE OBJECT OF ALL DEDICATED COMPANY EMPLOYEES
SHOULD BE TO ANALYSE THOROUGHLY ALL SITUATIONS;
ANTICIPATE ALL PROBLEMS PRIOR TO THEIR OCCURENCE;
HAVE ANSWERS TO ALL THESE PROBLEMS AND MOVE SWIFTLY
TO SOLVE THESE PROBLEMS WHEN CALLED UPON..
HOWEVER....
WHEN YOU ARE UP TO YOUR ARSE IN ALLIGATORS, IT IS
DIFFICULT TO REMIND YOURSELF THAT YOUR INITIAL
OBJECTIVE WAS TO DRAIN THE SWAMP!

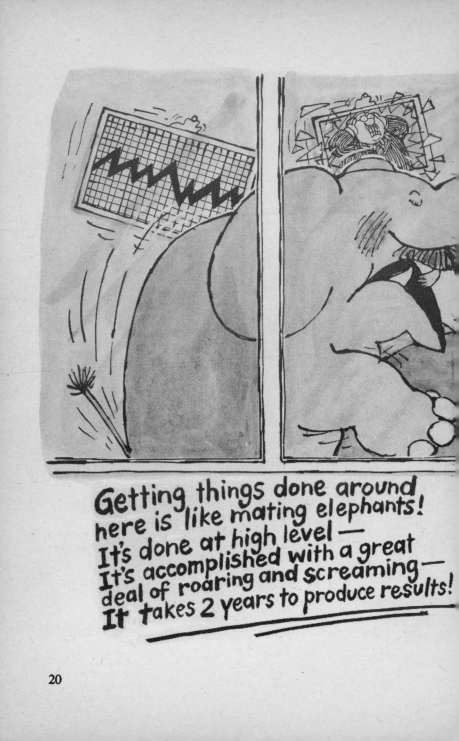

Getting things done around here is like mating elephants!
It's done at high level —
It's accomplished with a great deal of roaring and screaming —
It takes 2 years to produce results!

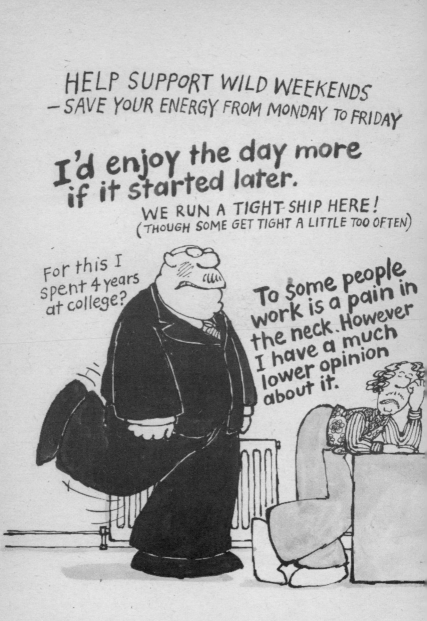

Customers giving orders will be promptly executed.

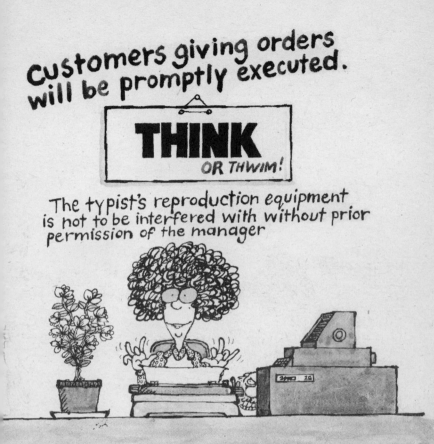

THINK
OR THWIM!

The typist's reproduction equipment is not to be interfered with without prior permission of the manager

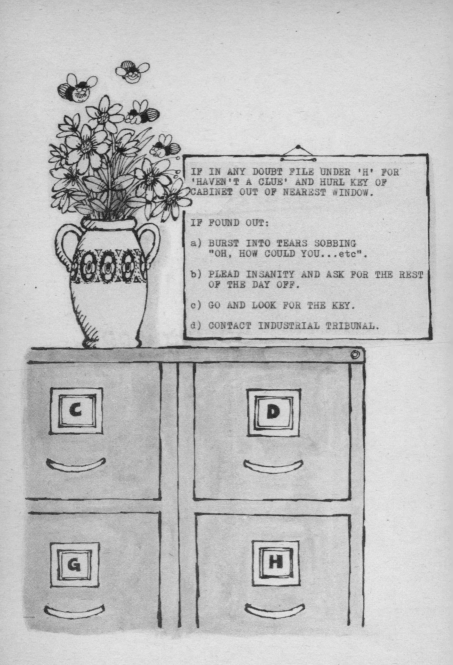

IF IN ANY DOUBT FILE UNDER 'H' FOR 'HAVEN'T A CLUE' AND HURL KEY OF CABINET OUT OF NEAREST WINDOW.

IF FOUND OUT:

a) BURST INTO TEARS SOBBING "OH, HOW COULD YOU...etc".

b) PLEAD INSANITY AND ASK FOR THE REST OF THE DAY OFF.

c) GO AND LOOK FOR THE KEY.

d) CONTACT INDUSTRIAL TRIBUNAL.

24

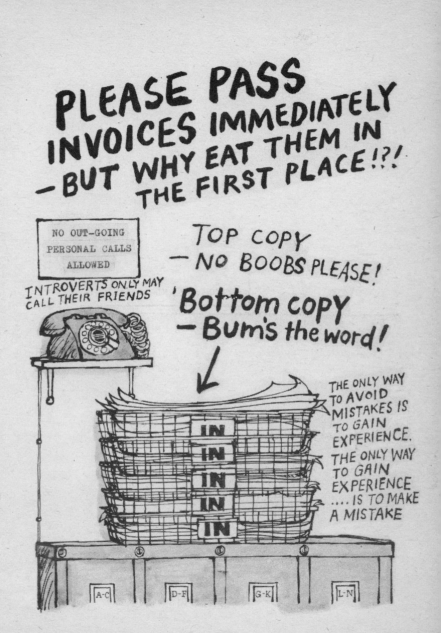

PLEASE PASS INVOICES IMMEDIATELY — BUT WHY EAT THEM IN THE FIRST PLACE!?!

NO OUT-GOING PERSONAL CALLS ALLOWED

INTROVERTS ONLY MAY CALL THEIR FRIENDS

TOP COPY — NO BOOBS PLEASE!

'Bottom copy — Bum's the word!

IN
IN
IN
IN
IN

THE ONLY WAY TO AVOID MISTAKES IS TO GAIN EXPERIENCE. THE ONLY WAY TO GAIN EXPERIENCE IS TO MAKE A MISTAKE

A-C D-F G-K L-N

IN BRIGHTON SHE WAS BRIDGET
SHE WAS PATSY UP IN PERTH
IN CAMBRIDGE SHE WAS CLARISSA
THE GRANDEST GIRL ON EARTH:
IN STAFFORD SHE WAS STELLA.
THE BEST OF ALL THE BUNCH,
BUT DOWN ON HIS EXPENSE ACCOUNT
SHE WAS PETROL, OIL AND LUNCH.

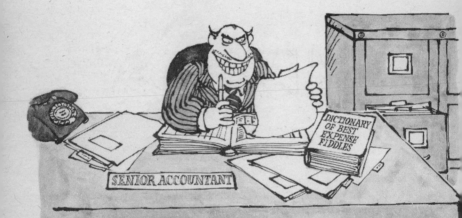

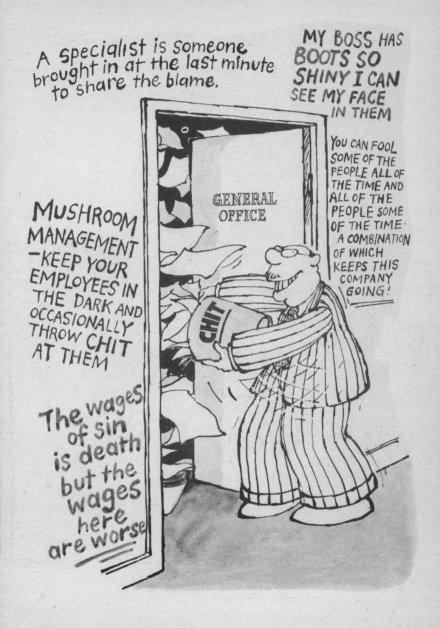

A specialist is someone brought in at the last minute to share the blame.

MY BOSS HAS BOOTS SO SHINY I CAN SEE MY FACE IN THEM

YOU CAN FOOL SOME OF THE PEOPLE ALL OF THE TIME AND ALL OF THE PEOPLE SOME OF THE TIME - A COMBINATION OF WHICH KEEPS THIS COMPANY GOING!

GENERAL OFFICE

MUSHROOM MANAGEMENT - KEEP YOUR EMPLOYEES IN THE DARK AND OCCASIONALLY THROW CHIT AT THEM

CHIT

The wages of sin is death but the wages here are worse

WILL THOSE EMPLOYEES WISHING FOR
LEAVE OF ABSENCE TO ATTEND THE
FUNERAL OF A GRANDMOTHER OR OTHER
CLOSE RELATIVE PLEASE INFORM THE
MANAGEMENT BEFORE TWELVE NOON
ON THE DAY OF THE MATCH.

IN THIS COMPANY WE LIVE IN DAYS OF WHINE & RISES

IF GOD HAD TIPPEX HE COULD BLOT OUT THE MISTAKES

If it wasn't for my faults, I'd be perfect

Pyramid Management- stepping on others to reach the top!

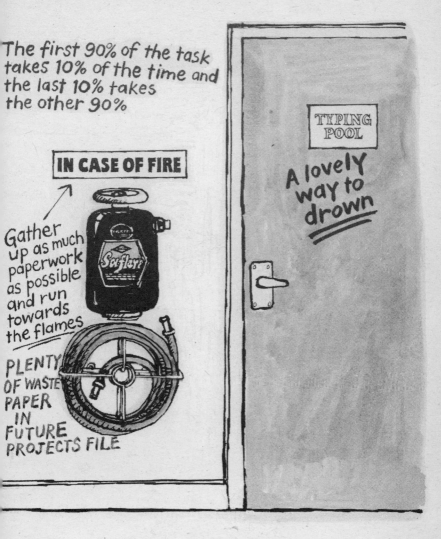

The first 90% of the task takes 10% of the time and the last 10% takes the other 90%

IN CASE OF FIRE

Gather up as much paperwork as possible and run towards the flames

PLENTY OF WASTE PAPER IN FUTURE PROJECTS FILE

TYPING POOL

A lovely way to drown

Keep Britain tidy —Kill a tourist!

At 35
Gauguin worked
in a bank.

It's never too late.

AT 35
MOZART WAS
DEAD!

ST. XIMIXIXIX SCHOOL OF ART, THE NU

Rugby
is a
game
played
by gentlemen
with
odd shaped
balls!

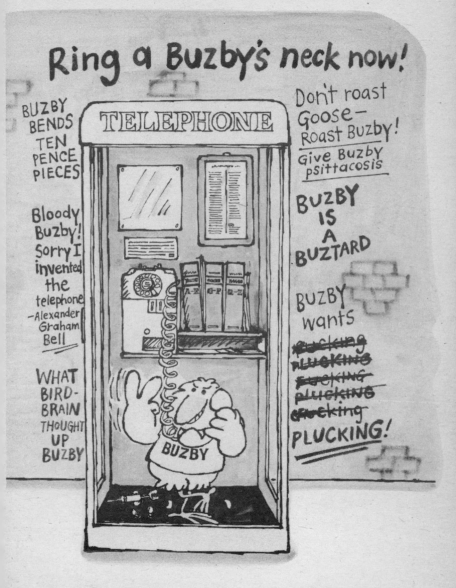

33

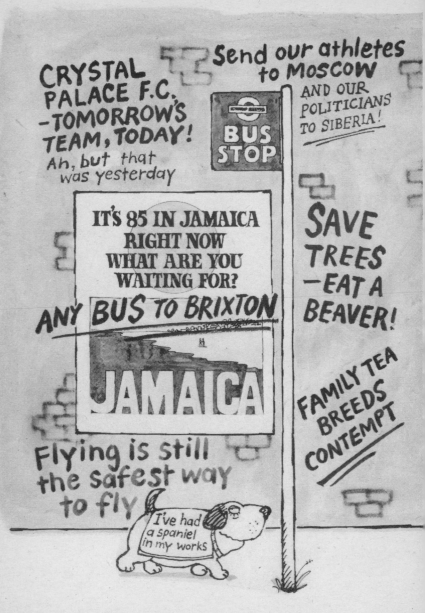

34

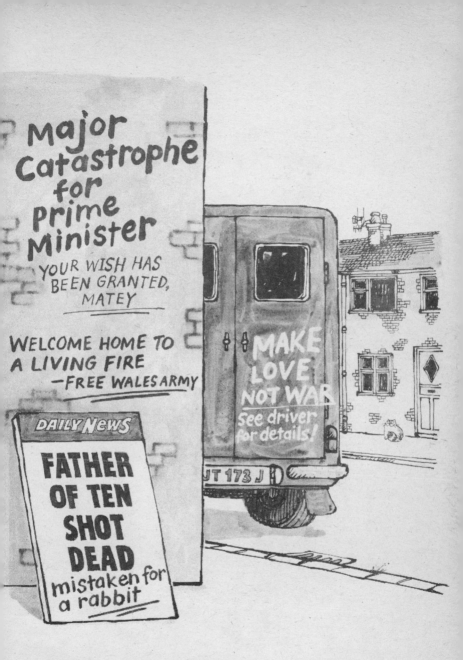

Major Catastrophe for Prime Minister

YOUR WISH HAS BEEN GRANTED, MATEY

WELCOME HOME TO A LIVING FIRE
—FREE WALES ARMY

DAILY NEWS

FATHER OF TEN SHOT DEAD
mistaken for a rabbit

MAKE LOVE NOT WAR
see driver for details!

UT 173 J

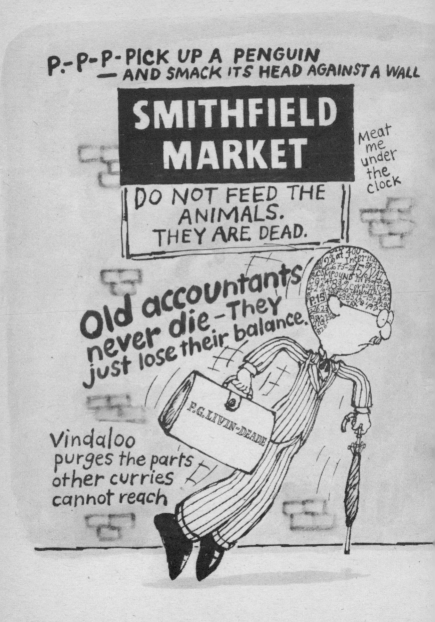

P.-P.-P.-PICK UP A PENGUIN
— AND SMACK ITS HEAD AGAINST A WALL

SMITHFIELD MARKET

Meat me under the clock

DO NOT FEED THE ANIMALS. THEY ARE DEAD.

Old accountants never die—They just lose their balance.

F.G.LIVIN-DEADE

Vindaloo purges the parts other curries cannot reach

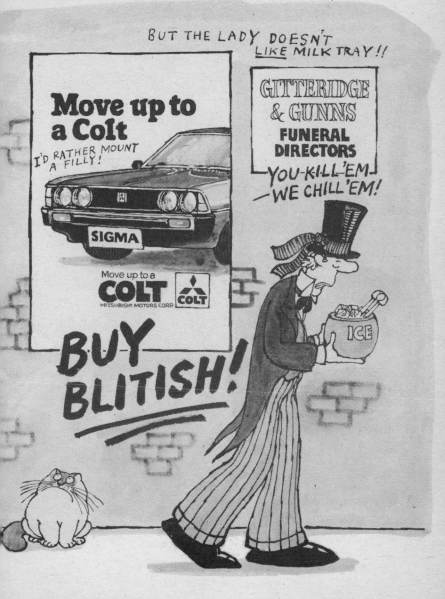

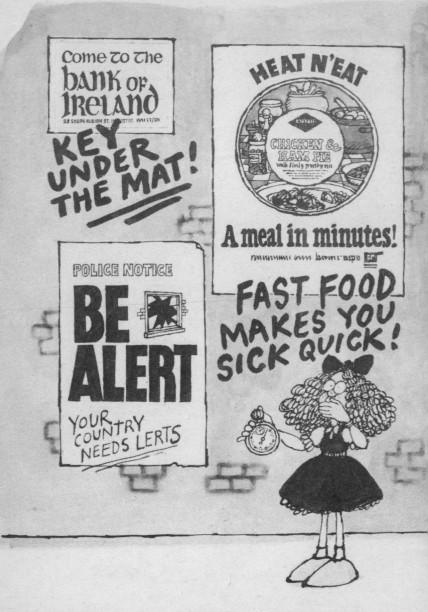

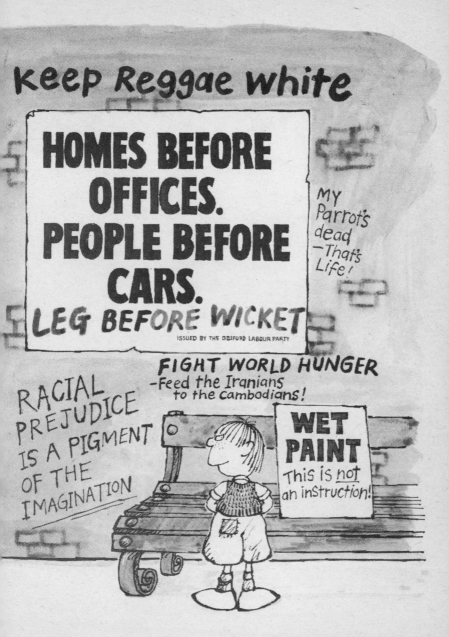

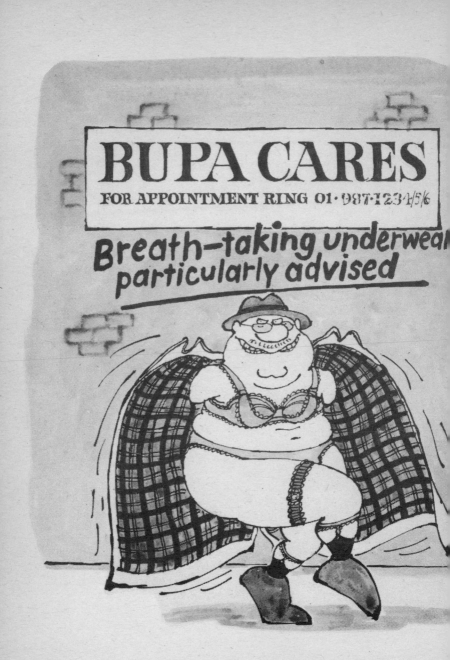

BELFAST WILL TAKE YOUR BREATH AWAY
— PERMANENTLY —

EAST LANE
TRAVEL BUREAU

629, PARTINGTON HIGH STREET, PELHAM TEL 22012/33011

Visit the Soviet Union
— before the
Soviet Union
visits you!!

When theres no more
room in HELL
the dead will walk
the EARTH

A FILM
ABOUT
CHARTERED
ACCOUNTANTS

ZOMBIES
DAWN OF THE DEAD (X)

Bad news – Good God?

43

GOD WAS
A WOMAN—
UNTIL SHE
CHANGED
HER MIND

J.C.
LOVES
M.E.

It's no good
trying to put
spilt milk
back into
the bottle

Religion is man's attempt
to communicate with
the weather.

REINCARNATION
IS A PLEASANT
SURPRISE.

Work for the Lord – The pay
is terrible but the fringe benefits
are out of this world!

CHURCH OF S: BARTHOLEMEW

ARE YOU TIRED OF SIN AND LONGING FOR A REST?

IF NOT, PHONE BAYSWATER 81762

Where will you be on the Day of Judgement?

STILL HERE, WAITING FOR A 31 BUS!

SUFFER LITTLE CHILDREN

Especially those with transistor radios!!!

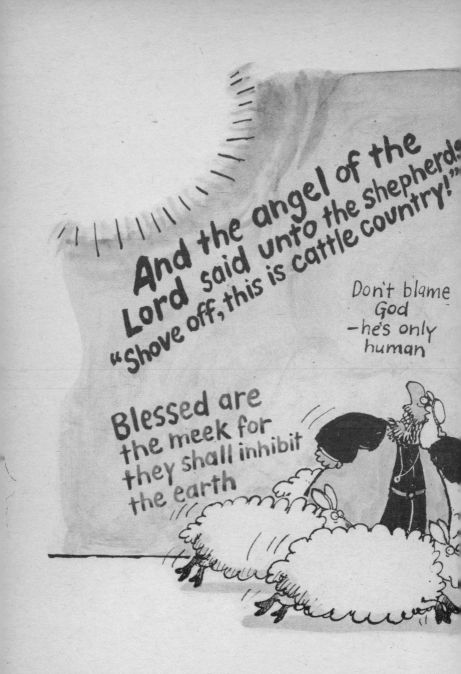

THE POPE LIVES IN A VACUUM

Jews are like everyone else
—only more so!

CHRIST DID NOT SAY
—'KILL TREES FOR CHRISTMAS'
Jog for Jesus

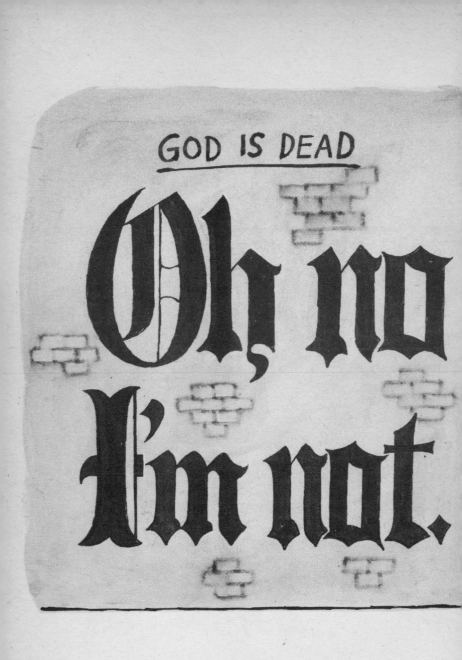

GOD IS DEAD

Oh, no
I'm not.

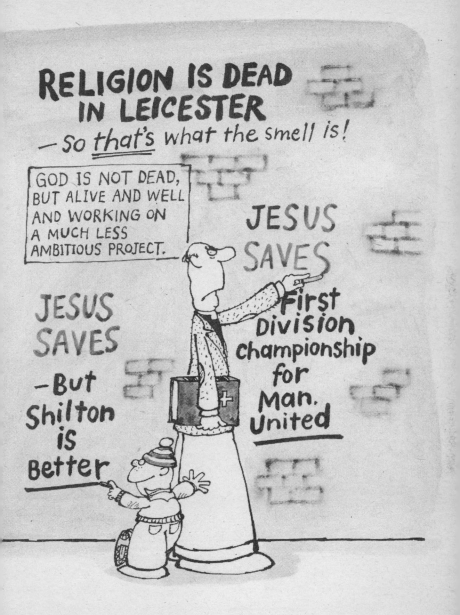

RELIGION IS DEAD IN LEICESTER

— So *that's* what the smell is!

GOD IS NOT DEAD, BUT ALIVE AND WELL AND WORKING ON A MUCH LESS AMBITIOUS PROJECT.

JESUS SAVES
— But Shilton is Better

JESUS SAVES First Division championship for Man. United

Freedom for all
—What's yours is mine
and what's mine
is my own!

53

I'M A REGULAR DRUG-TAKER — I TAKE ANDREWS

Cannibalise legalis — Eat a lawman today

Let him who is stoned cast the first sin.

A friend with weed is a friend indeed. But a friend in need is a PEST!!

The grass is greener in Tiajuana

55

56

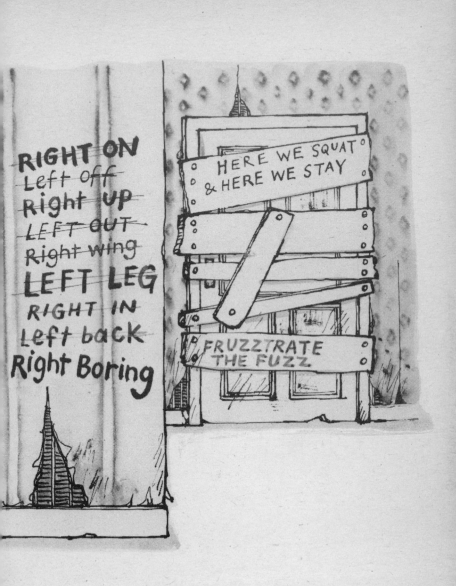

RIGHT ON
Left off
Right up
LEFT OUT
Right wing
LEFT LEG
RIGHT IN
Left back
Right Boring

HERE WE SQUAT
& HERE WE STAY

FRUZZTRATE
THE FUZZ

I hate graffiti
— Dirty rats, they killed
my brother!

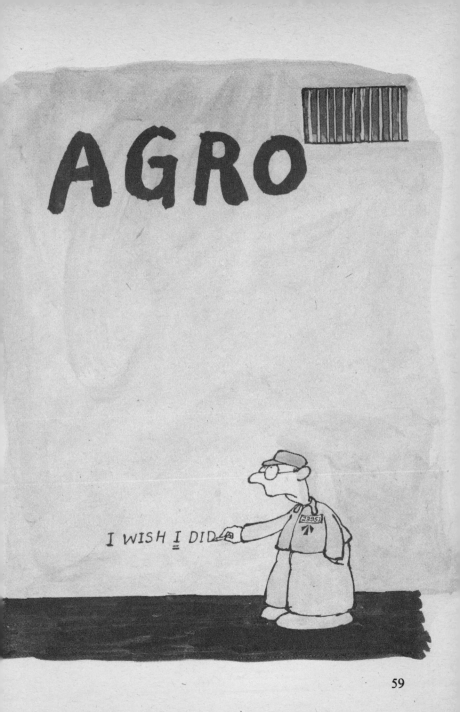

Humpty Dumpty
was pushed

MY WIFE HAD HAD THE CHANGE OF LIFE
SO I THOUGHT I'D HAVE A CHANGE OF WIFE
—AND NOW THEY'VE SENT ME DOWN FOR LIFE

Free the Heinz 57

Free Chile!

NO THANKS, HONEY, I'SE ALREADY GOT ONE

FREE GEORGE DAVIS
—WITH EVERY PACKET
OF CORNFLAKES

If Jesus saves
he must be
working a
tax fiddle

61

I WAS IN REFUSE DISPOSAL IN BELFAST
— DISPOSING OF THOSE WHO REFUSE!

Don't make a fool out
of me – I'm doing OK by myself.

GIVE A MAN
ENOUGH ROPE
AND HE'LL HANG YOU

Hanging concentrates
the mind wonderfully
IT ALSO CURES CONSTIPATION

We are all
under control

I AM HERE BECAUSE
I'M AN ARSIST
surely you
mean 'arsonist'.
I KNOW WHAT
I MEAN, DUCKIE!

Three-channel
TV sets – Guaranteed
perfect working order
– As advertised on 'POLICE 5'

Evil spelt backwards is live

WE'LL HAVE
PEACE IN ULSTER
IF WE HAVE TO KILL
EVERYONE TO DO IT.

Don't burn
your bridges
until you come
to them.

A rat's a rat
for a' that!

YOU HAVE TO
TAKE THE
BAD WITH
THE WORST

Poetry is when every line begins with a capital!

OUST
PROUST

Fiction is
a fact.

SHAKESPEARE
SUCKED BACON
DRY

Alas poor
kciroy
—I knew him
backwards

Biggles flies
back to front

OTHELLO WAS
A BIGOT

65

NATURE

SHAKESPEARE
BRINGS HOME
THE BACON

Words mean
nothing today!

T.S. Eliot is an
anagram of
Toilets

Tolkien is
Hobbit-forming

TOLKIEN
SPOKIEN
HERE

The only
good
books
are read
ones

Frodo has
been busted!

Mozambique is full of black Marx.

HERMAN MELVILLE EATS BLUBBER

Henry James must have f**cked somebody

I wandered lonely as a cloud because I had B.O.

SEXTON BLAKE LOVES TO HAVE A TINKER

It's a good job that William Ewart Gladstone is dead. He's been buried an awful long time!

MOUNTAINEERING

69

Insanity is hereditary
—You get it from
your kids!

I wish I were what I was when I wished I were what I am.

NECESSITY IS THE MOTHER OF CONVENTION

Lead in the atmosphere can affect one's I.Q. — especially if it drops on one's head.

IS THERE LIFE BEFORE DEATH?

When you talk to me — SHUT UP!

Going to a psychiatrist didn't cure my drink problem — I kept falling off the couch!

I either want less corruption — or more chance to participate in it!

I USED TO HAVE MONEY TO BURN — AND MY LOVER WAS THE BEST MATCH.

Does oral sex mean just talking about it?

You're a better man than I, Mrs Dinn — Gunga

A CIGAR IS ONLY A CIGAR BUT A OOD WOMAN IS A POKE

MARY HAD A LITTLE LAMB WITH WHICH SHE USED TO SLEEP TOO LATE SHE FOUND IT WAS A RAM AND NOW SHE HAS A LITTLE LAMB

WHO SCREWED LOOBY LOO? — ANDY RANDY!

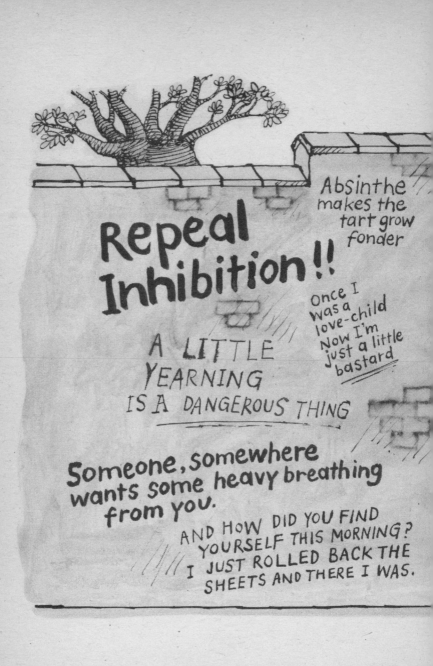

Repeal
Inhibition!!

Absinthe makes the tart grow fonder

A LITTLE YEARNING IS A DANGEROUS THING

Once I was a love-child Now I'm just a little bastard

Someone, somewhere wants some heavy breathing from you.

AND HOW DID YOU FIND YOURSELF THIS MORNING? I JUST ROLLED BACK THE SHEETS AND THERE I WAS.

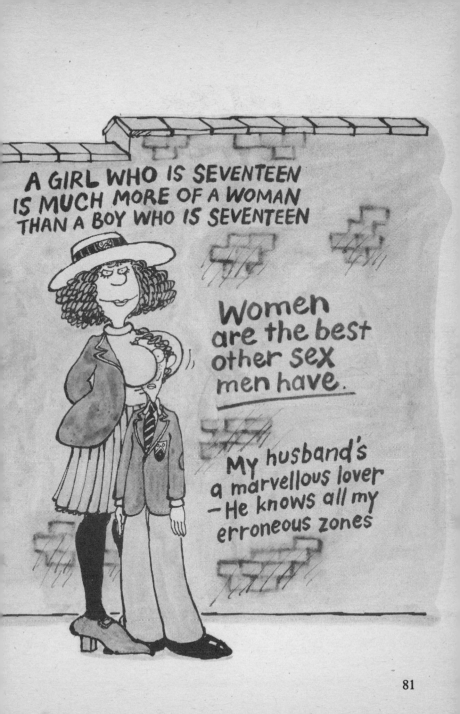

WOMEN TEND TO GET ALL JUMPY DURING THEIR MINSTREL PERIODS

If jewellery is a collection of jewels, flattery is a collection of flats and pantry is a collection of pants then what is coquetry?

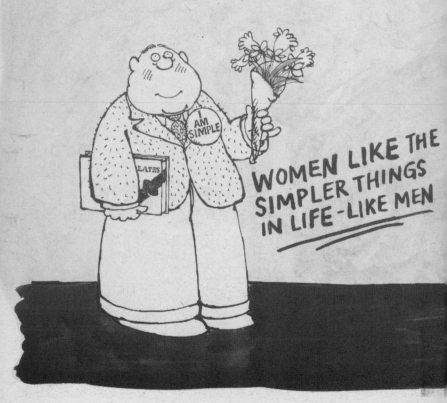

WOMEN LIKE THE SIMPLER THINGS IN LIFE - LIKE MEN

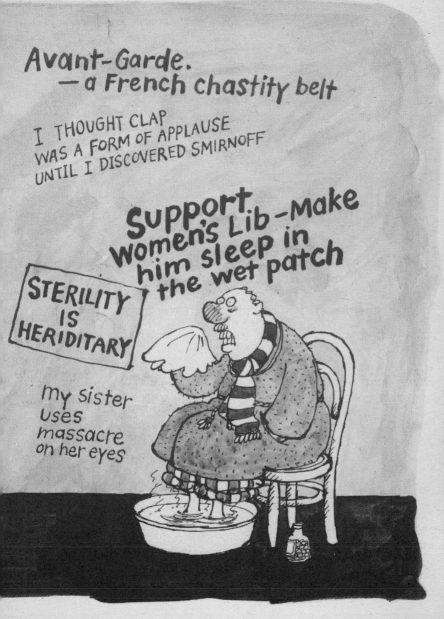

Avant-Garde.
— a French chastity belt

I THOUGHT CLAP
WAS A FORM OF APPLAUSE
UNTIL I DISCOVERED SMIRNOFF

Support
women's Lib-Make
him sleep in
the wet patch

STERILITY
IS
HERIDITARY

my sister
uses
massacre
on her eyes

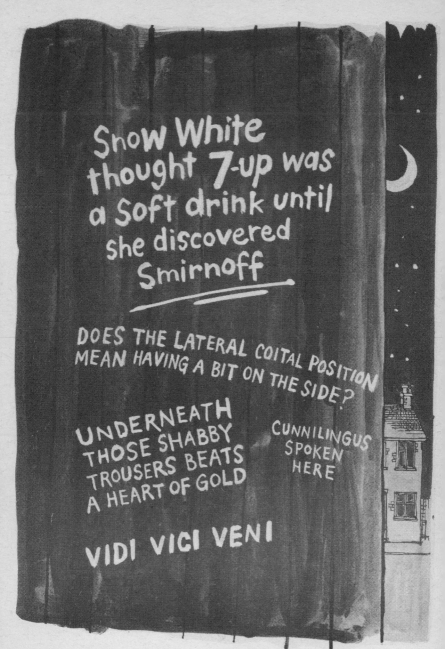

Snow White thought 7-up was a soft drink until she discovered Smirnoff

DOES THE LATERAL COITAL POSITION MEAN HAVING A BIT ON THE SIDE?

UNDERNEATH THOSE SHABBY TROUSERS BEATS A HEART OF GOLD

CUNNILINGUS SPOKEN HERE

VIDI VICI VENI

TEXANS
ARE LIVING
PROOF THAT
INDIANS SCREWED
BUFFALOES

Time in loo –Take a holiday –Let your trousers down!

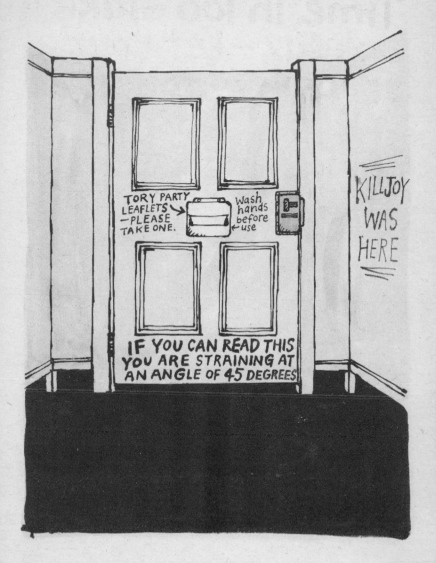

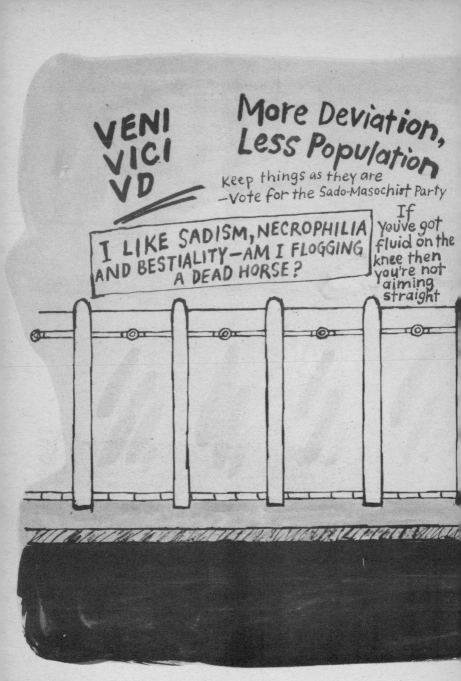

VENI
VICI
VD

More Deviation, Less Population

Keep things as they are
—Vote for the Sado-Masochist Party

I LIKE SADISM, NECROPHILIA AND BESTIALITY—AM I FLOGGING A DEAD HORSE?

If you've got fluid on the knee then you're not aiming straight

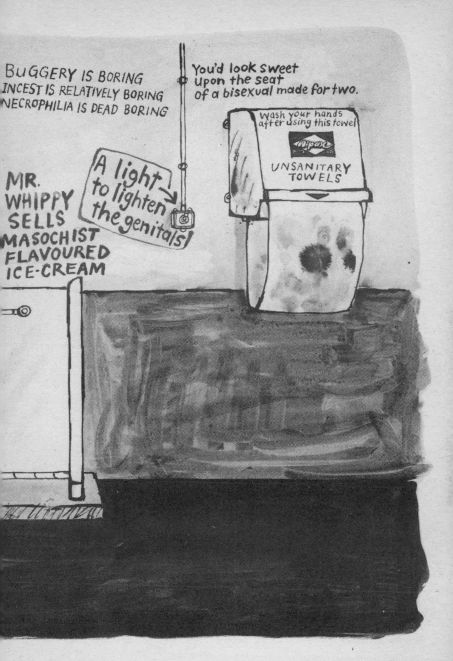

BUGGERY IS BORING
INCEST IS RELATIVELY BORING
NECROPHILIA IS DEAD BORING

You'd look sweet
Upon the seat
of a bisexual made for two.

Wash your hands
after using this towel

Mipore

UNSANITARY
TOWELS

MR.
WHIPPY
SELLS
MASOCHIST
FLAVOURED
ICE-CREAM

A light
to lighten
the genitals!

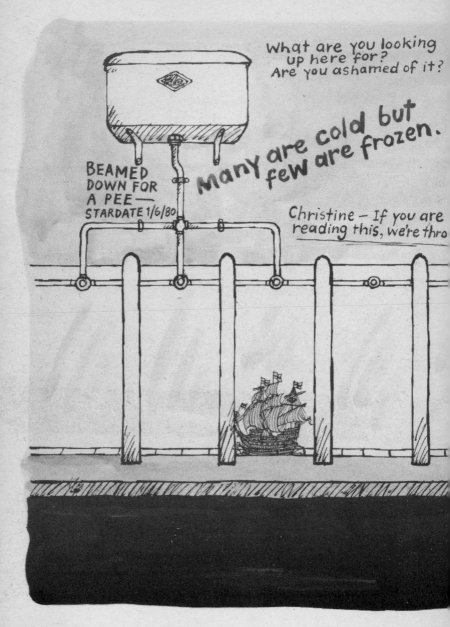

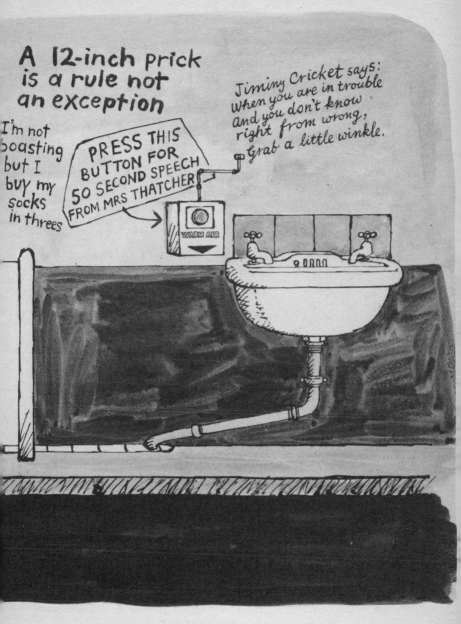

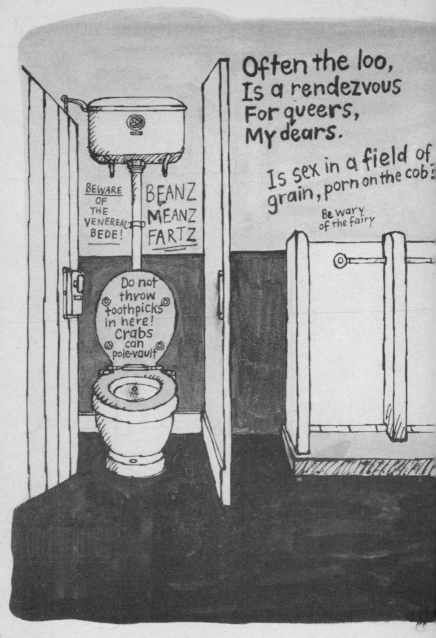

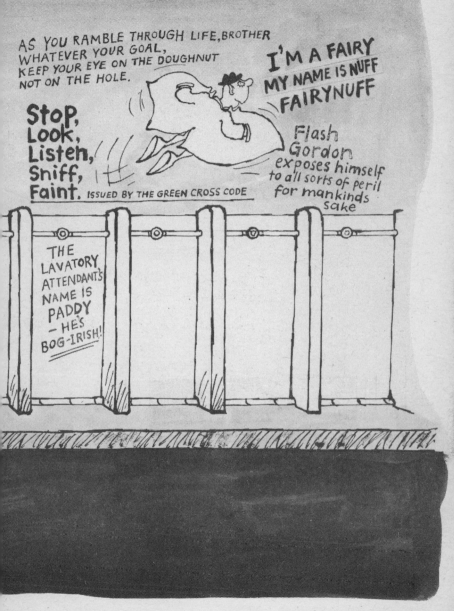

AS YOU RAMBLE THROUGH LIFE, BROTHER
WHATEVER YOUR GOAL,
KEEP YOUR EYE ON THE DOUGHNUT
NOT ON THE HOLE.

I'M A FAIRY
MY NAME IS NUFF
FAIRYNUFF

Stop,
Look,
Listen,
Sniff,
Faint. ISSUED BY THE GREEN CROSS CODE

Flash
Gordon
exposes himself
to all sorts of peril
for mankinds
sake

THE
LAVATORY
ATTENDANTS
NAME IS
PADDY
— HE'S
BOG-IRISH!

Since writing on lavatory walls is done neither for personal acclaim nor financial reward, it must be the purest form of art. Discuss.